Don't Worry, Be Happy

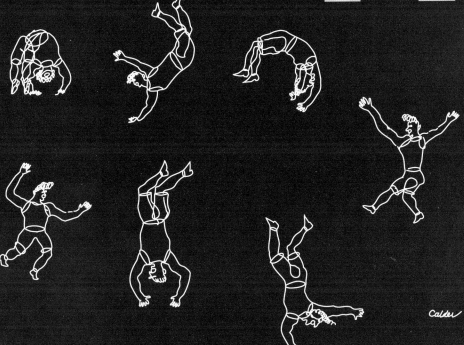

Lyrics by
Bobby McFerrin

Art by
Alexander Calder

Edited by Linda Sunshine

Welcome Books

NEW YORK ● SAN FRANCISCO

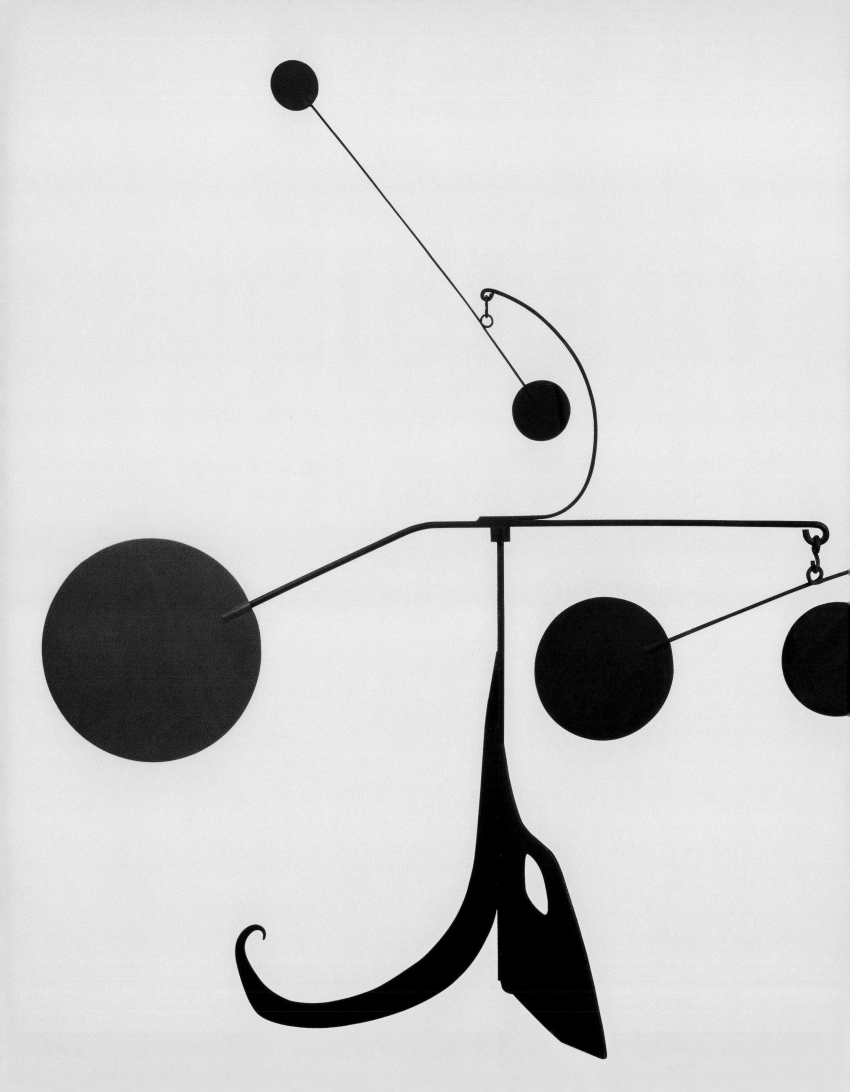

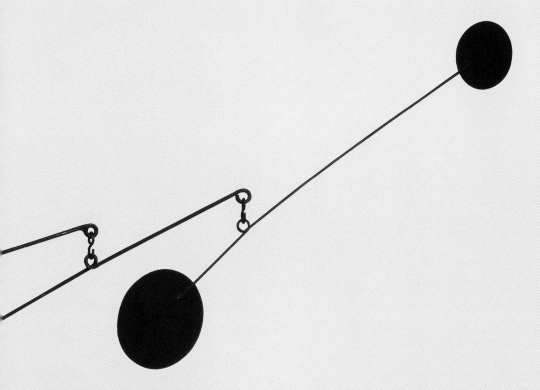

Here's a little song
I wrote
You might
want to sing it
note for note

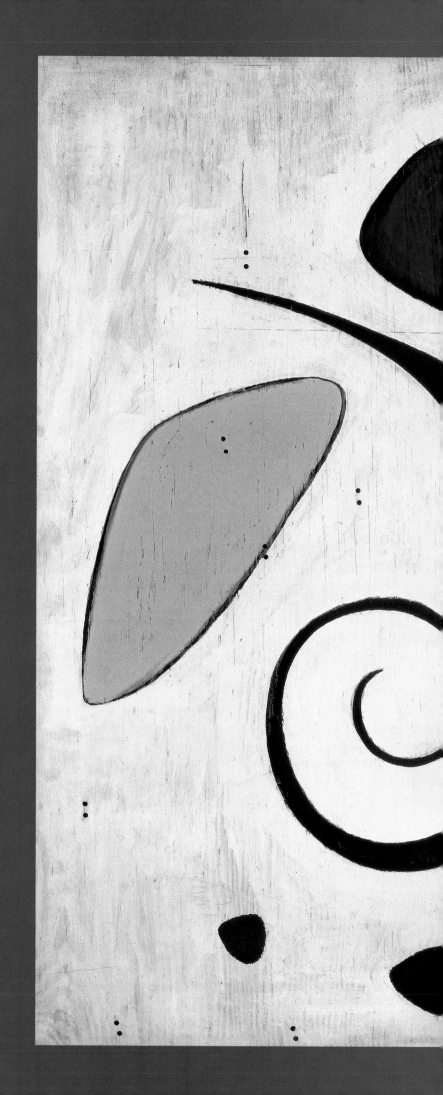

Don't
worry,
be
happy

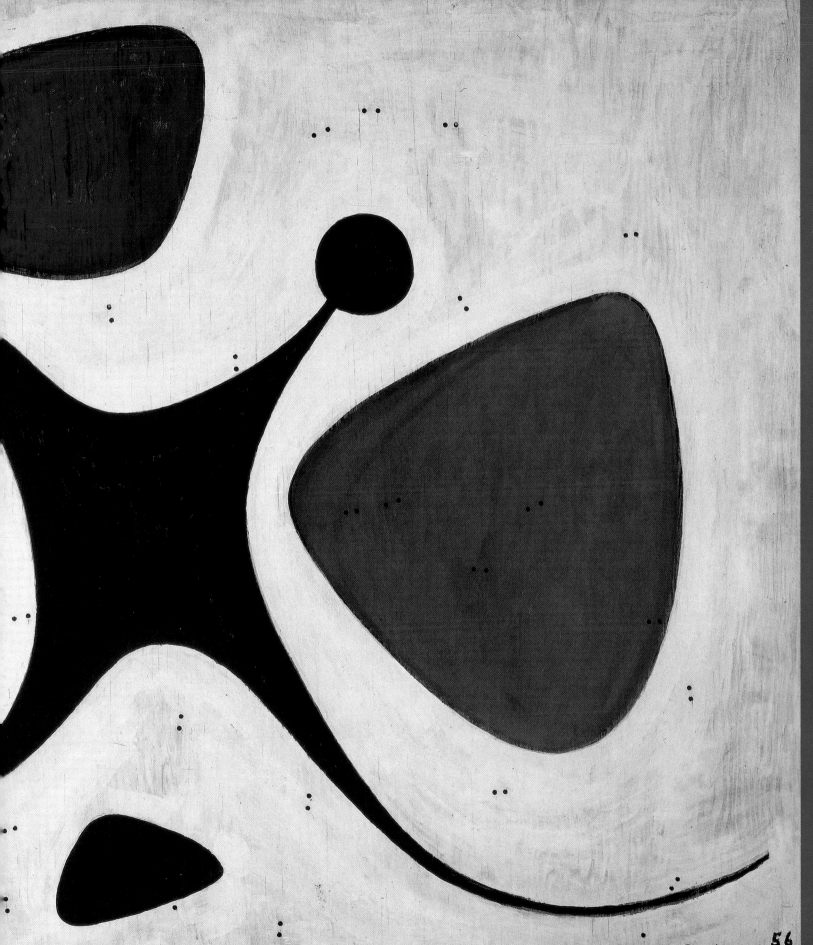

Calder 56

In every life we have
some trouble
But when you worry
you make it double

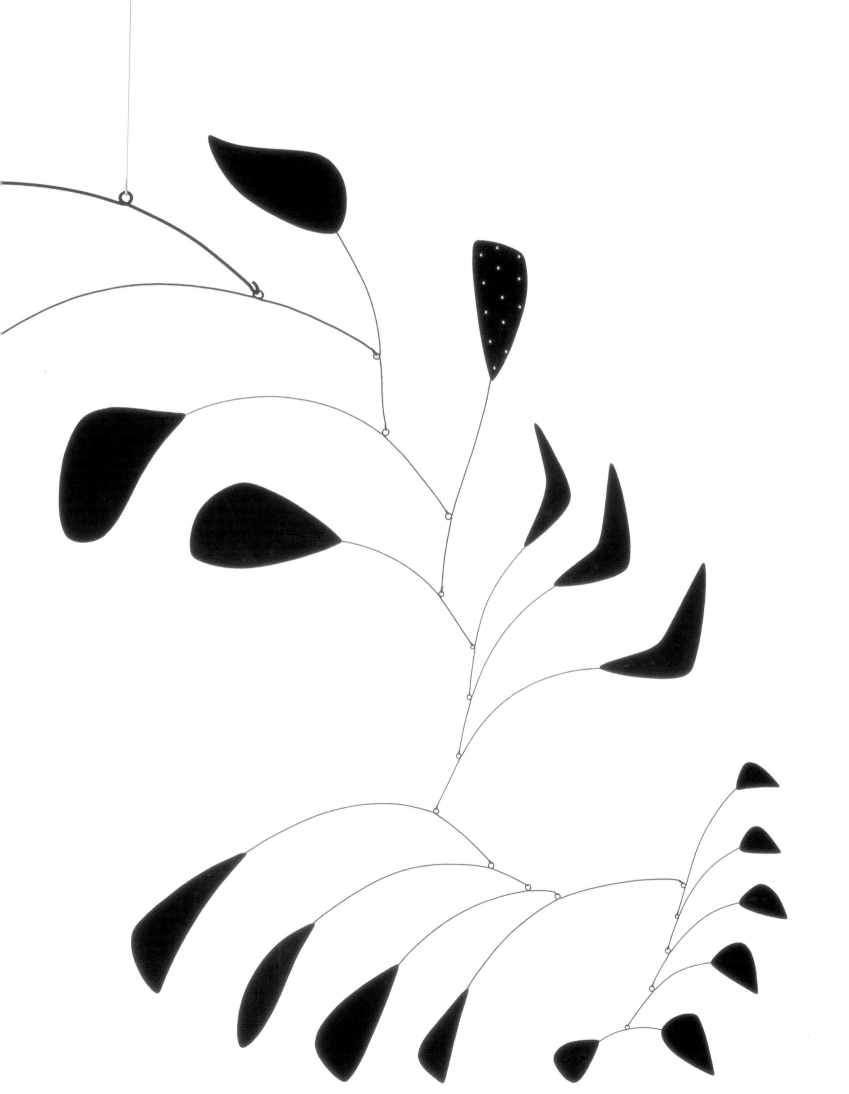

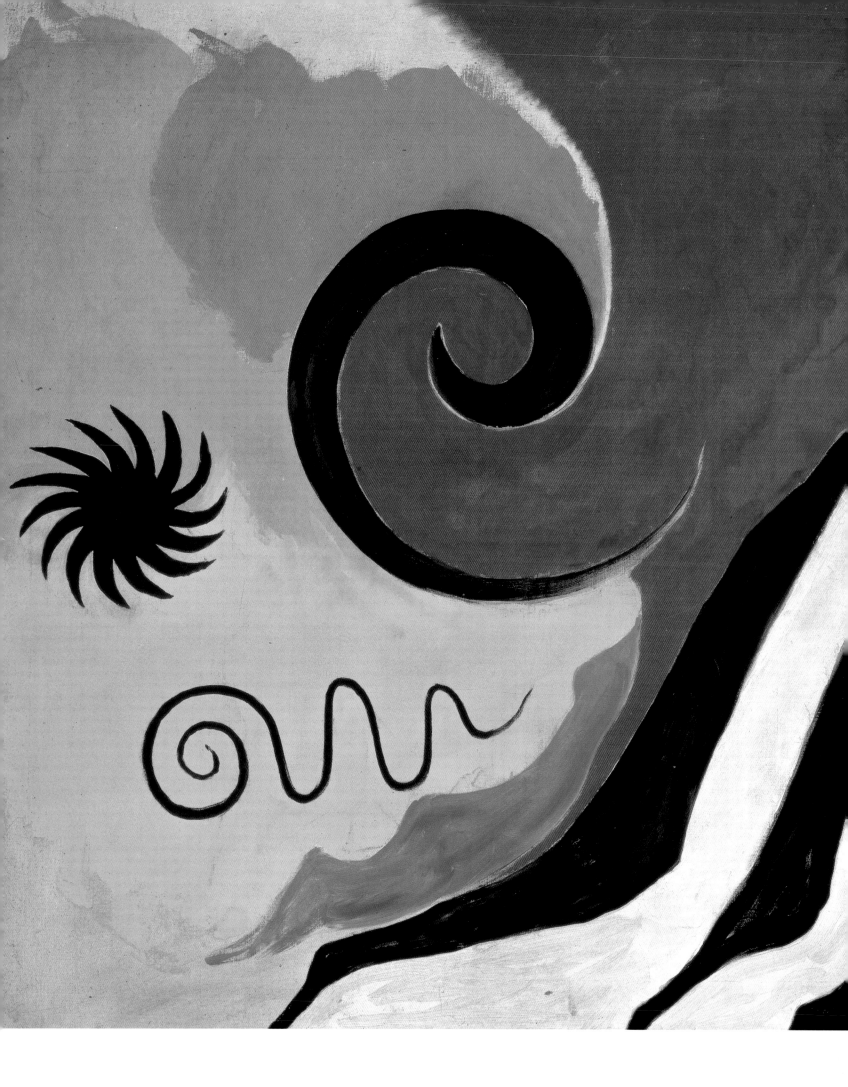

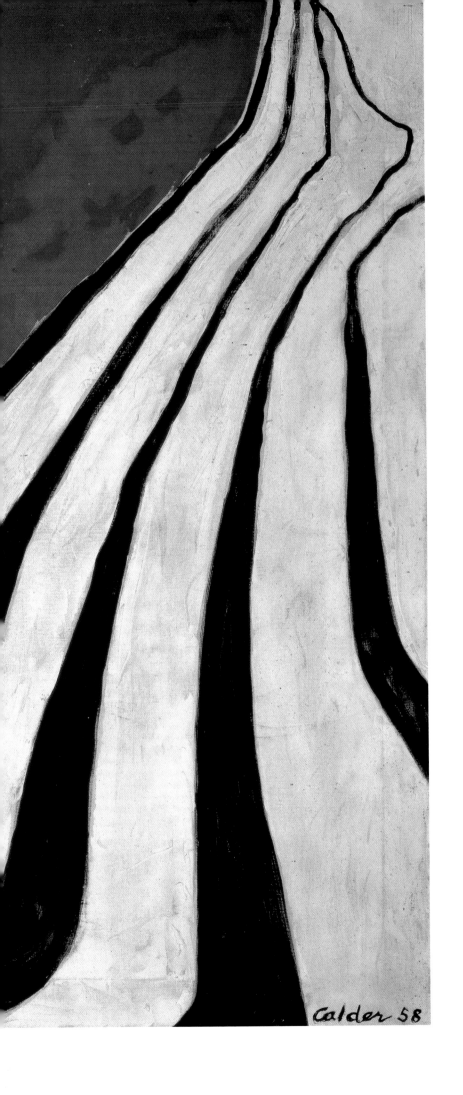

Calder 58

Don't
worry,
be
happy

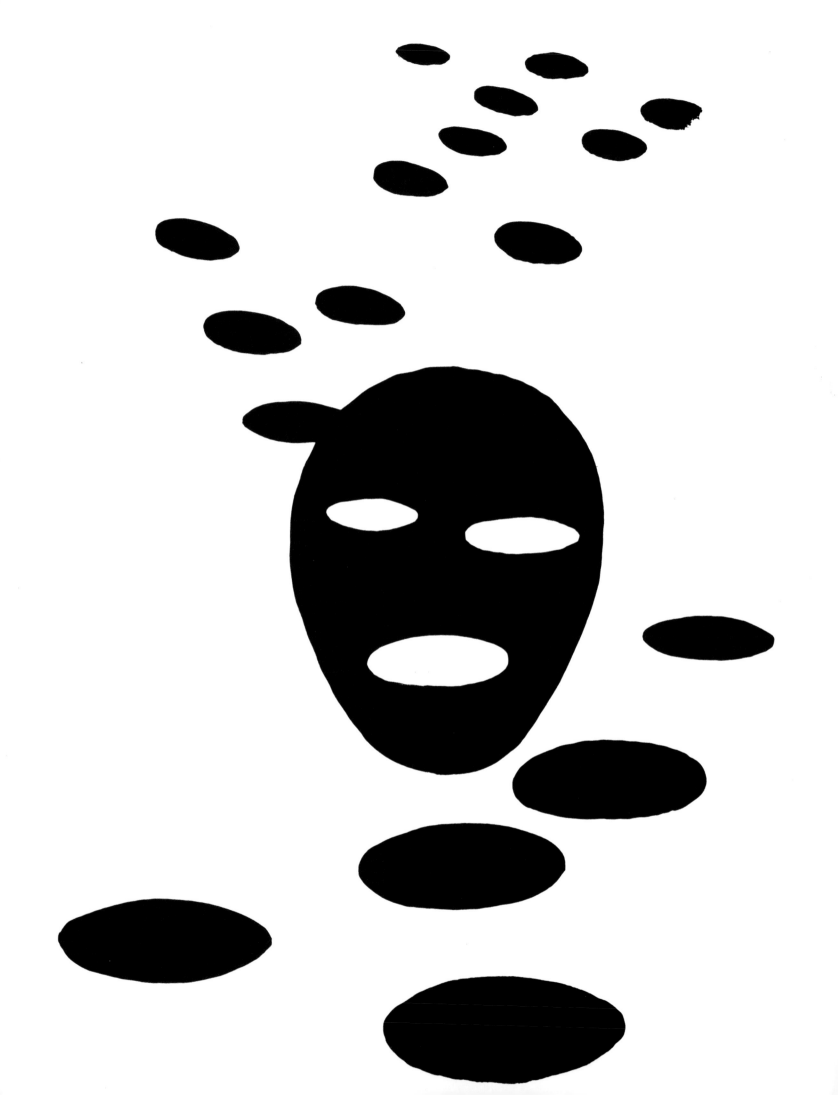

Ain't got no place
to lay your head,
Somebody came
and took your bed

Don't worry, be happy

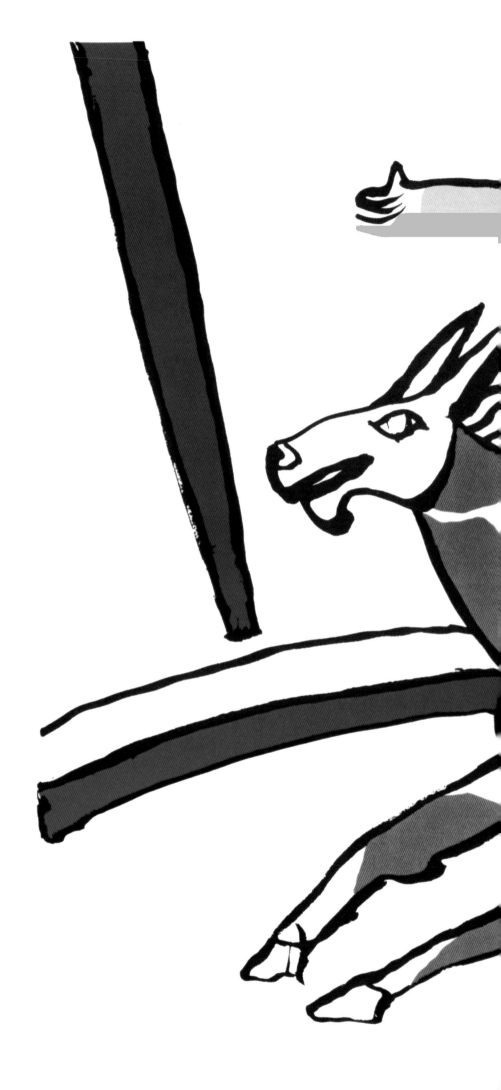

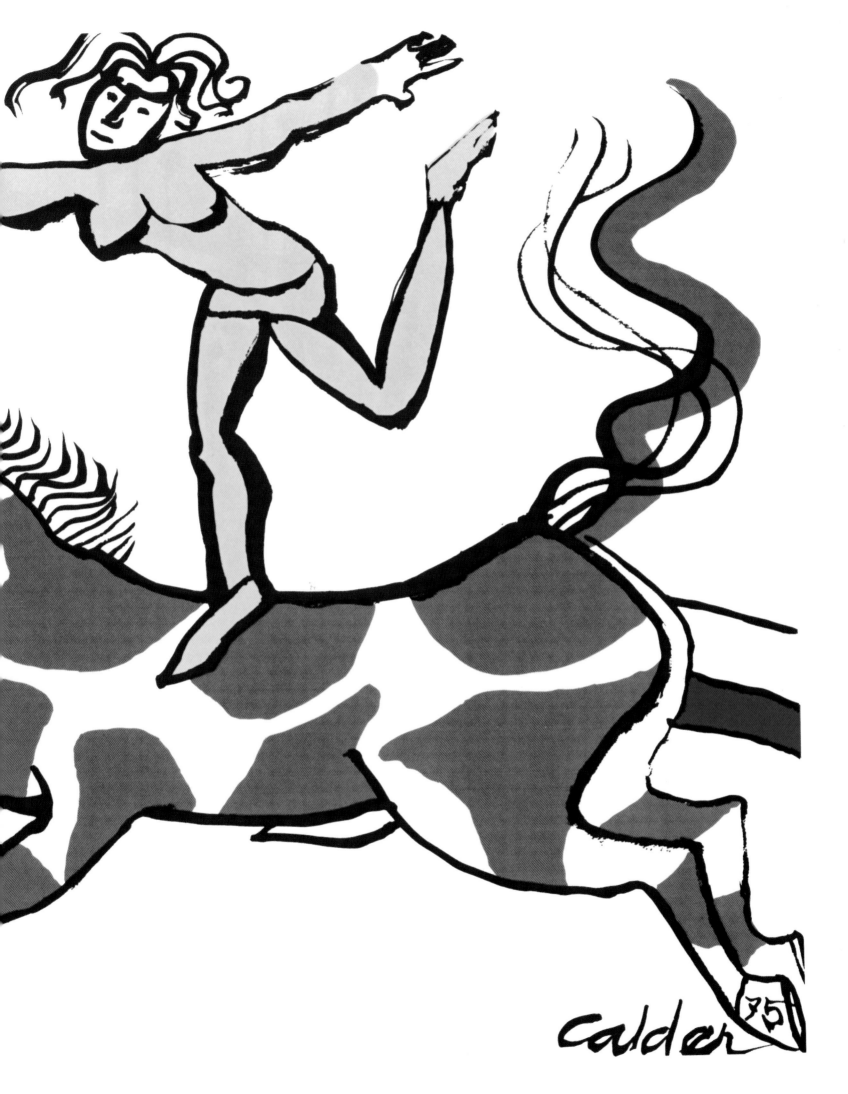

The landlord say
your rent is late,
he may have
to litigate

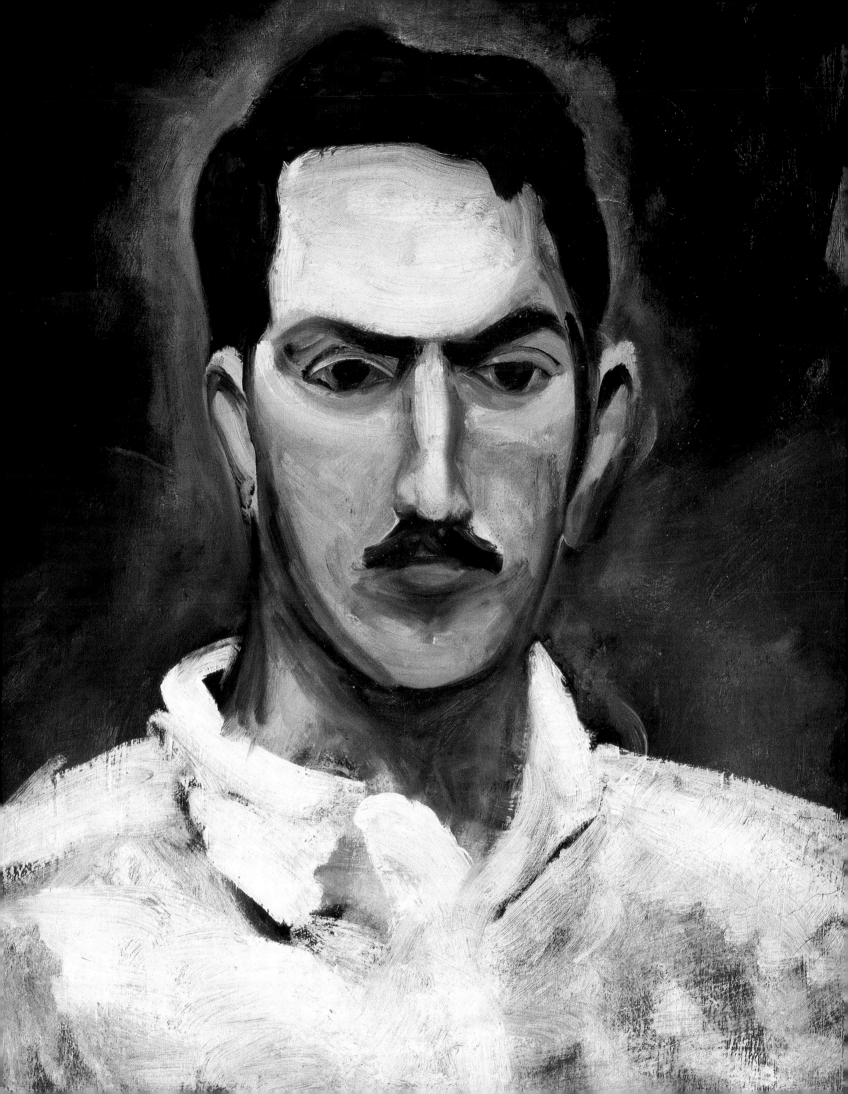

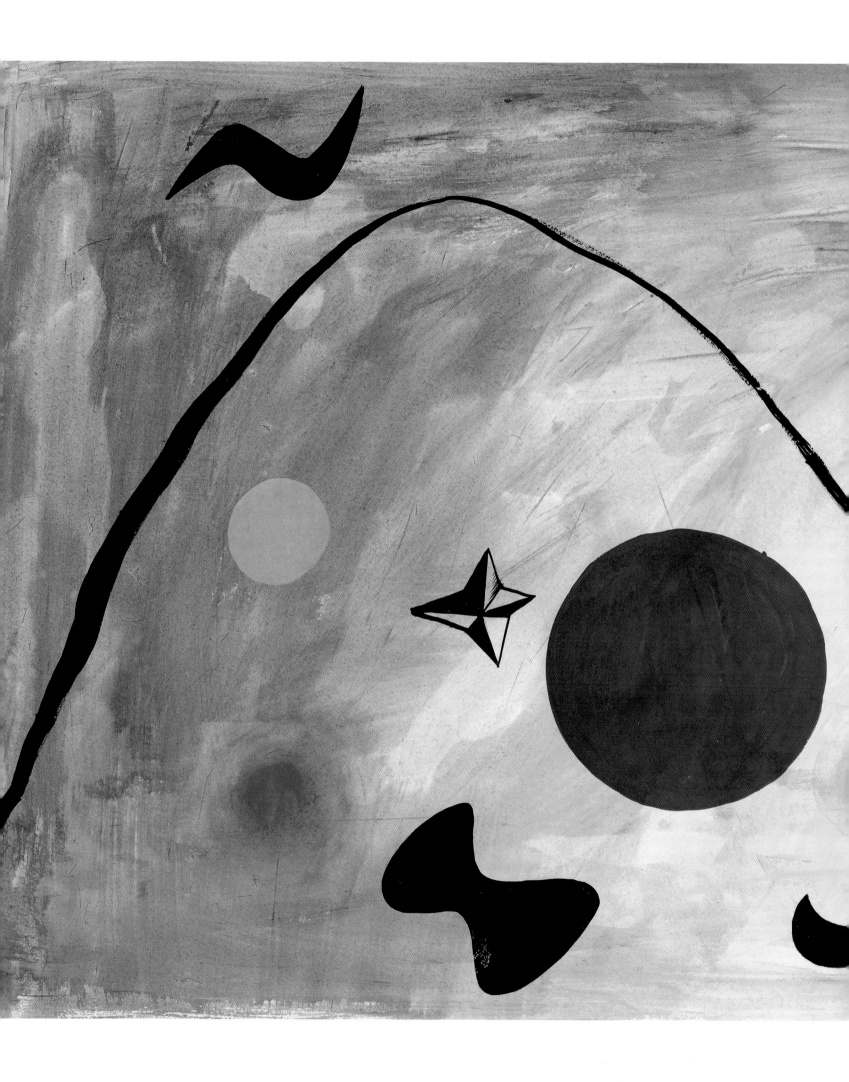

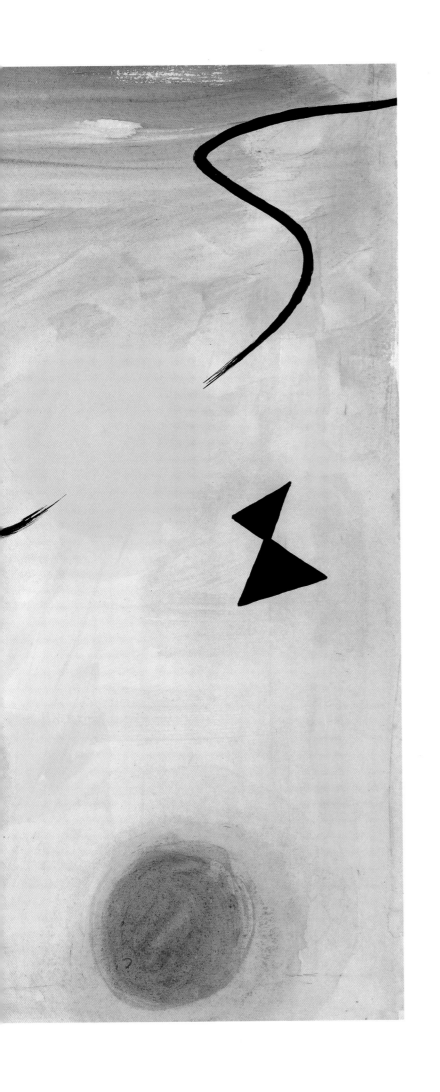

Don't worry, be happy

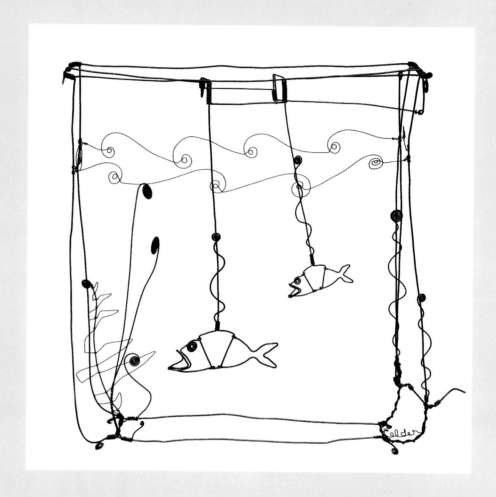

Ain't got no cash
Ain't got no style

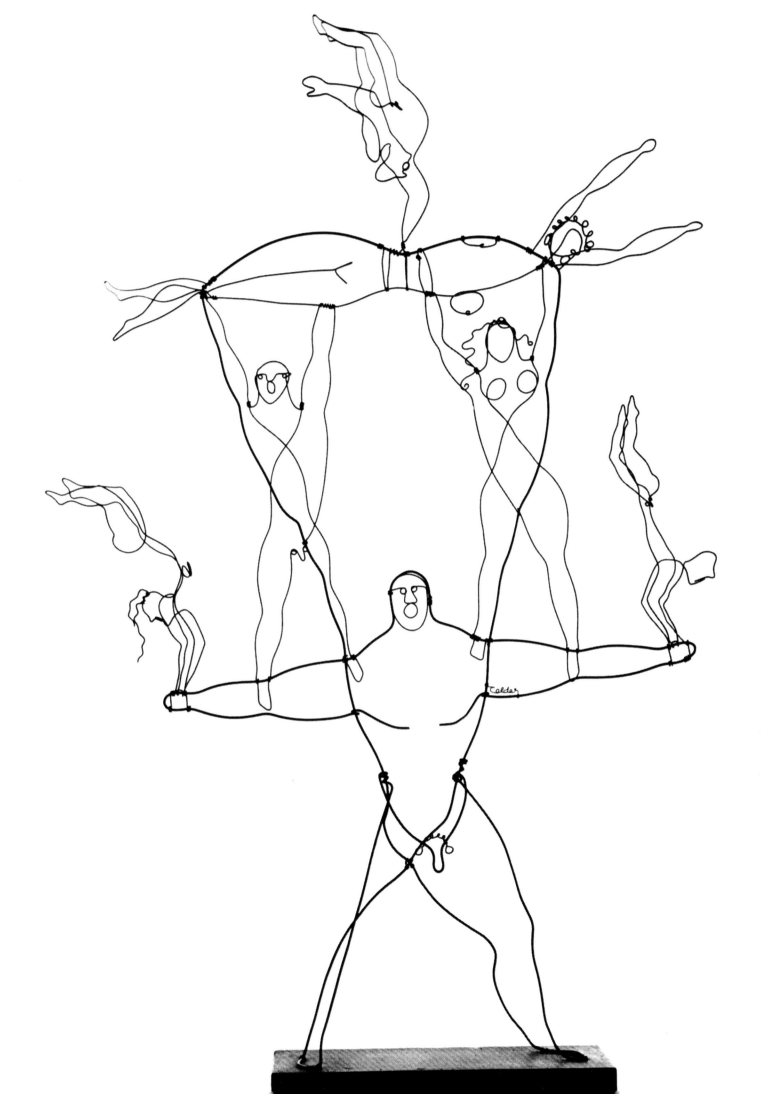

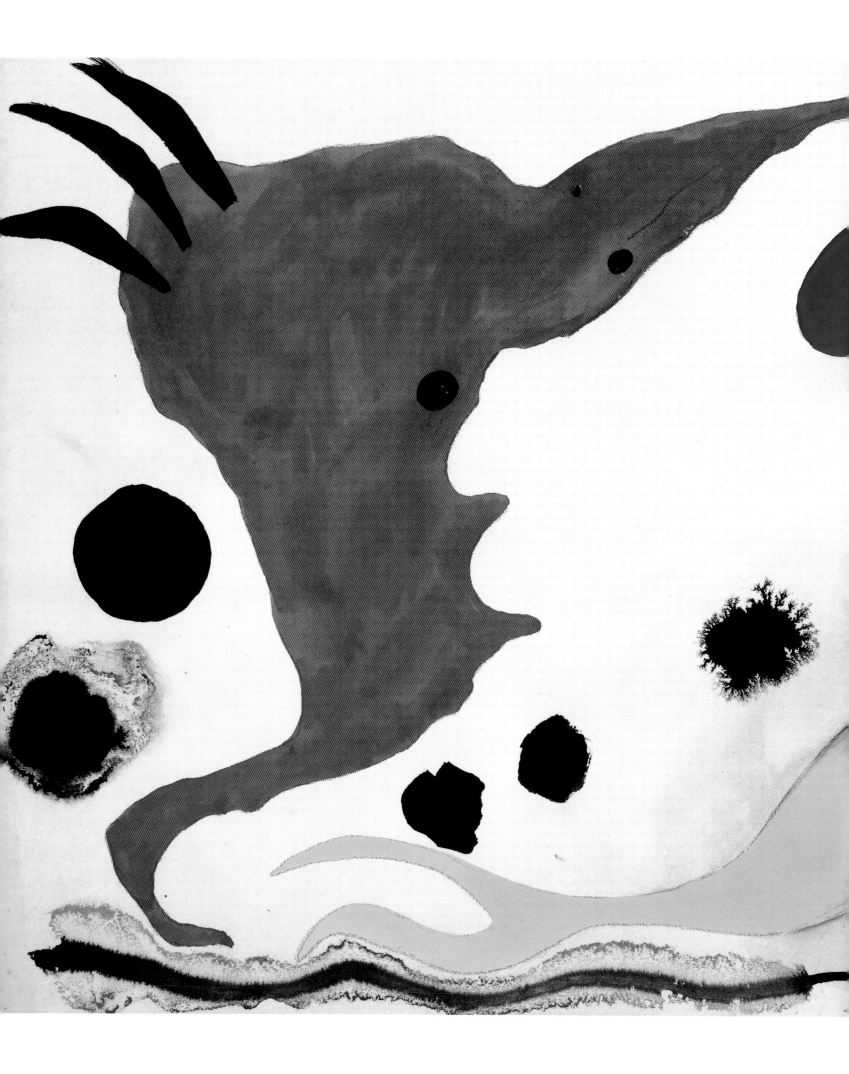

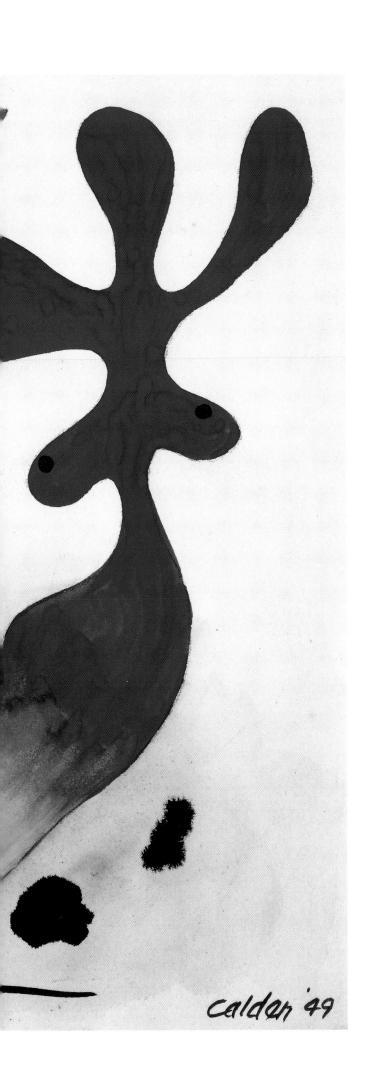

Calder '49

Ain't got
no gal
to make
you smile

Don't
worry,
be
happy

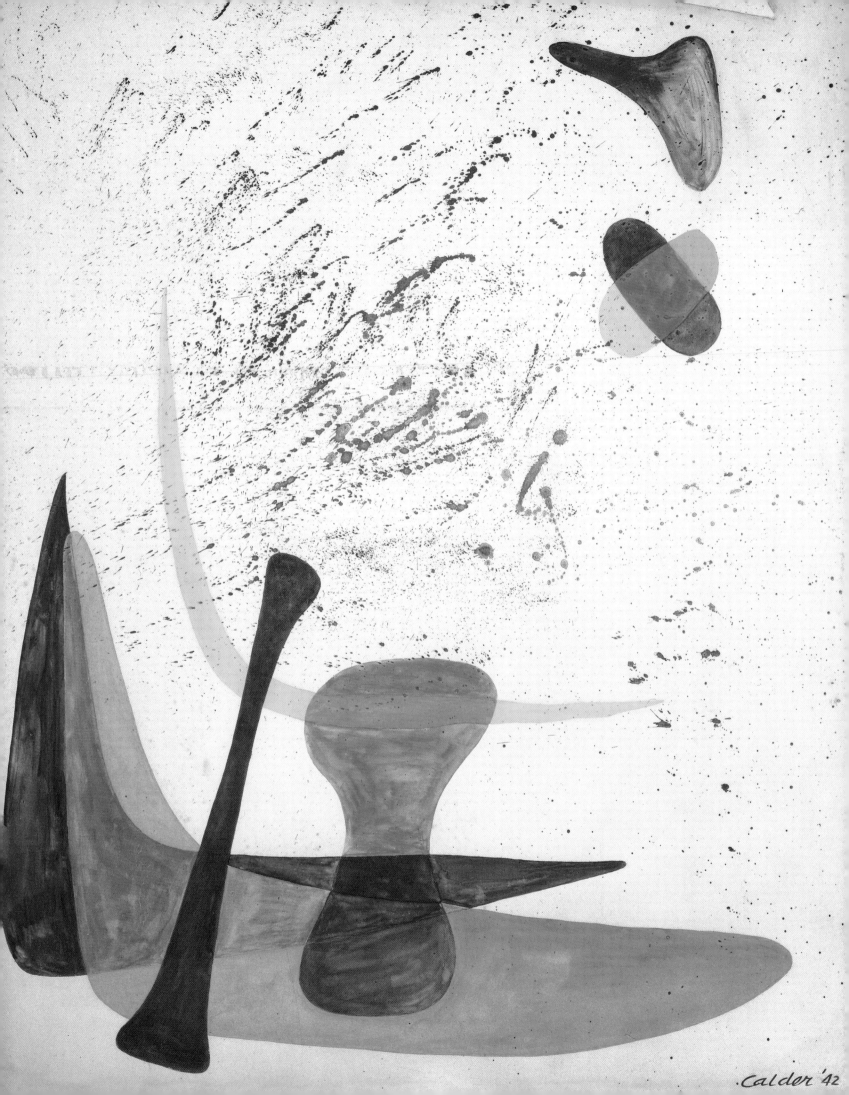

Calder '42

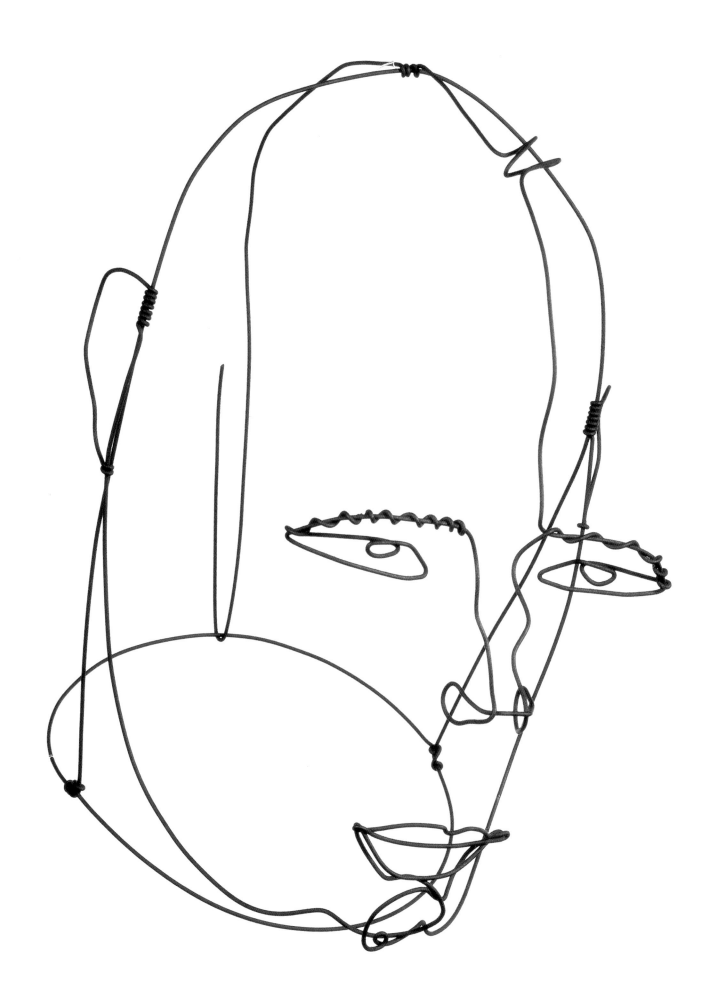

Cause when
you worry
your face
will frown

and that
will bring
everybody
down

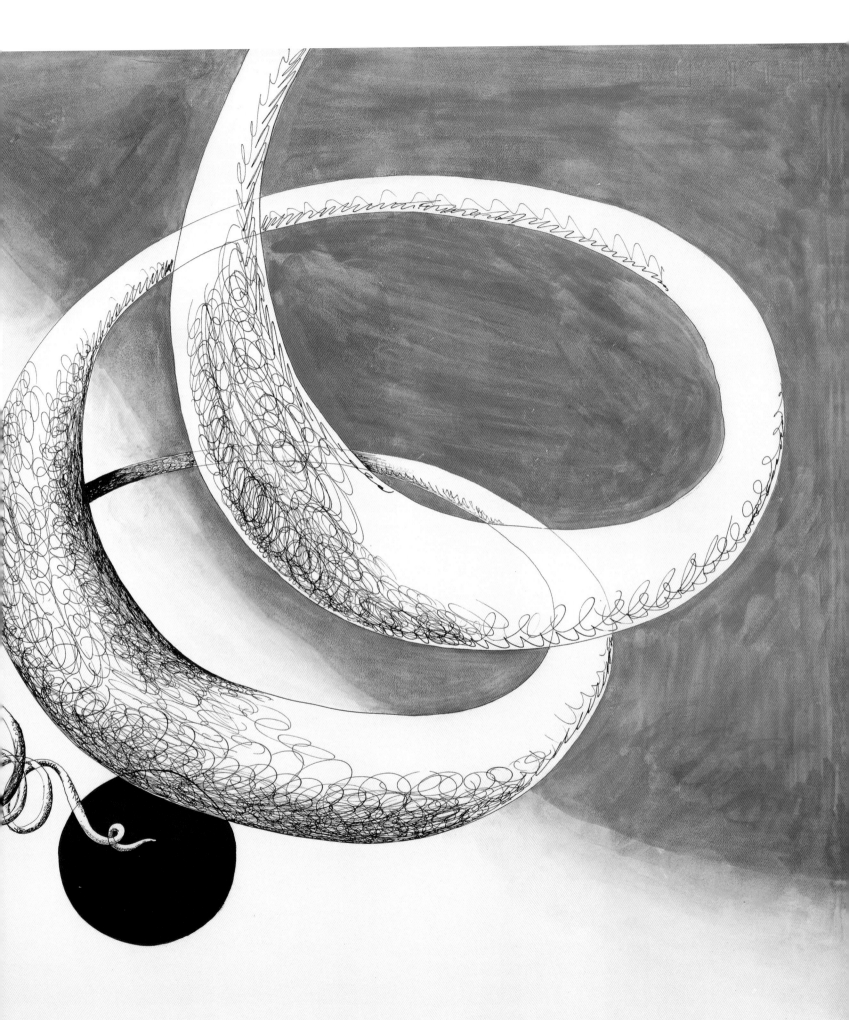

Calder 1932

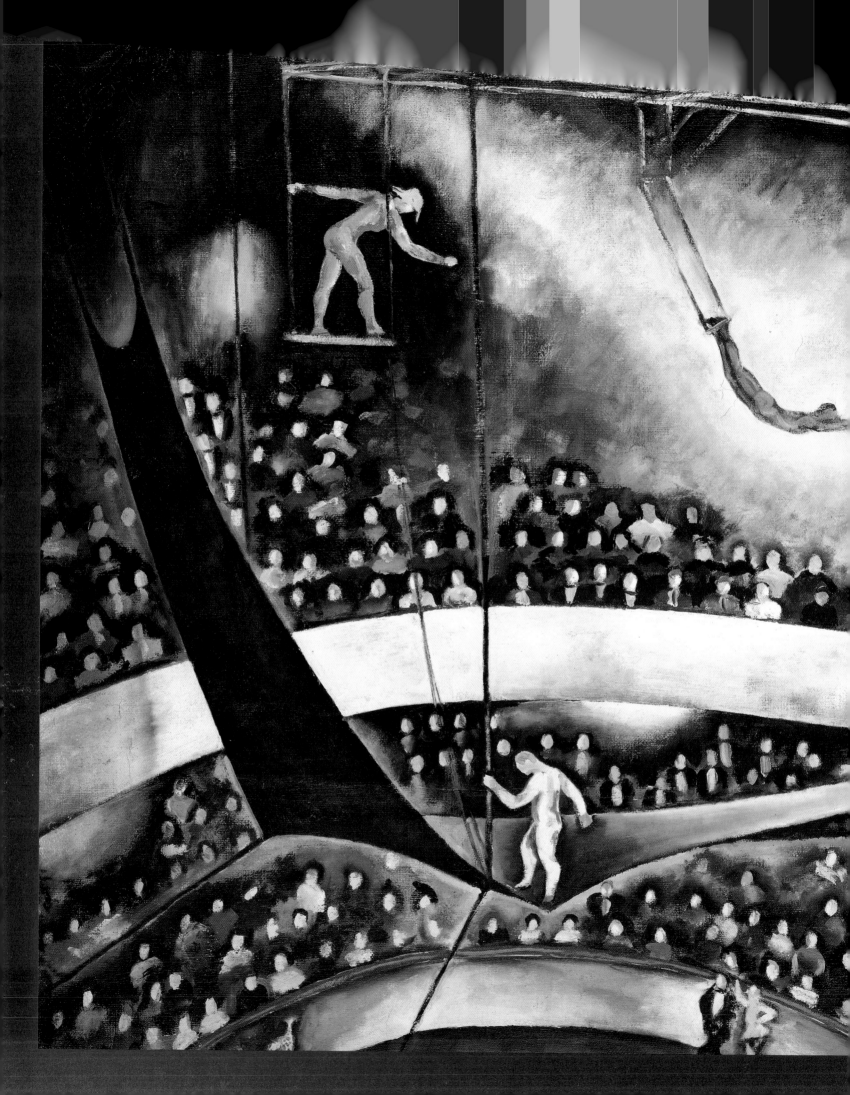

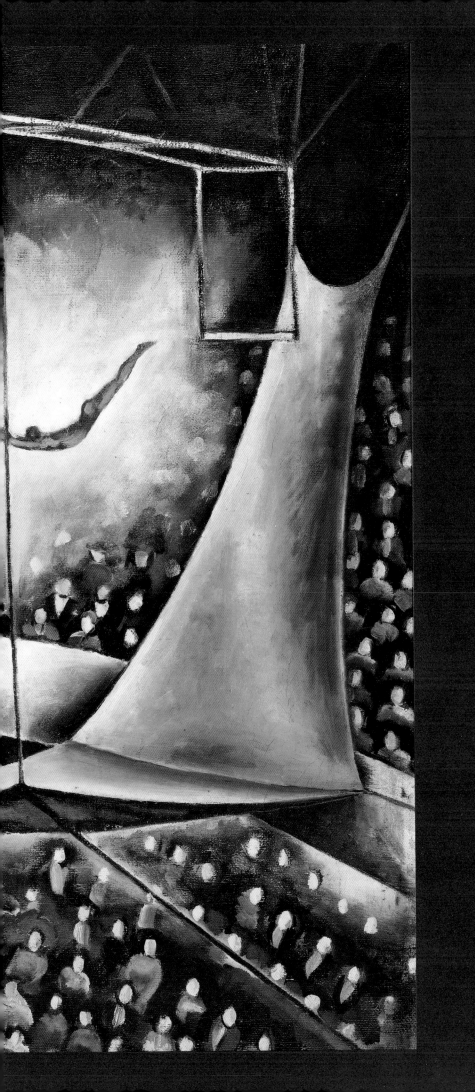

Don't
worry,
**be
happy**

"One of the simplest and most direct ways of praying and meditating is through singing."
—BOBBY MCFERRIN

BORN TO TWO CLASSICAL SINGERS IN NEW YORK CITY on March 11, 1950, **BOBBY MCFERRIN** began studying musical theory at age 6. The piano was his primary instrument in high school and college. In 1977 he moved to San Francisco where he met Bill Cosby who arranged for McFerrin's 1980 debut at the Hollywood Bowl. McFerrin released his first album, *Bobby McFerrin*, in May 1982.

Since then McFerrin has become one of the most innovative voices in jazz, conducted some of the world's greatest orchestras, and recorded a #1 pop single in the process. After ten Grammy awards, a formidable career as a conductor of classical music, TV and film appearances as well as millions of records sold, Bobby McFerrin is clearly recognized as an artist of joyous and profound depth and virtuosity.

In the development of his solo vocal work, the caliber of McFerrin's art has remained effortlessly innovative. In 1983 he stood on-stage alone, with microphone in hand, singing a seemingly impossible alternation of bass lines and melody, using his body to resonate with an uncanny and unstoppable rhythm. Bobby McFerrin at once pioneered a new approach to singing, a rare accomplishment in this century.

McFerrin's recordings and performances over the last thirteen years cover a wide musical terrain. Occasionally he was accompanied by artists like Herbie Hancock, Wayne Shorter, and Robin Williams, but above all he concentrated on his solo adventures. His 1992 record for Blue Note, *Play*, was an inspired improvisatory jazz romp with master collaborator, Chick Corea, while the simultaneously released *Hush*, a duet with world-renowned cellist Yo Yo Ma, was a critical and commercial success.

Bobby McFerrin has no musical boundaries. Like a select handful of musicians (Wynton Marsalis or Andre Previn, for example), he's maintained a flourishing career in jazz and a classical music reputation at the same time. McFerrin has the ability to bring his music to a wide spectrum of listeners to ultimately become a pop phenomenon as well. He achieved unparalleled, commercial success as a one-man vocal ensemble with his multi-platinum album *Simple Pleasures* (1988), which included the landmark "Don't Worry, Be Happy," a song that has sold over 20 million copies, won Song of the Year, and been #1 in almost every industrial nation in the world. Since his debut recording in 1982, McFerrin has been featured in popular television commercials for Ocean Spray® and Levi's® jeans, sang the weekly theme for "The Cosby Show," created an ACE award-winning video, "Spontaneous Invention," and sang the theme music for Bertrand Tavernier's film "Round Midnight," another Grammy award-winning performance. The entire soundtrack to the children's video *How the Camel Got His Hump* consists of McFerrin's unique vocals.

In addition to his busy conducting schedule, McFerrin has formed two touring groups, a jazz trio called Bang Zoom, and Voicestra, a vocal group. He's also recorded an album of original jazz compositions with members of the Yellowjackets and continues to do unaccompanied solo performances.

The year 2001 brings McFerrin multiple conducting engagements, including his debut with the Vienna Philharmonic, a new emphasis on choral music, extensive composing, and recording. He remains one of the most innovative, multifaceted, and beloved artists of his generation.

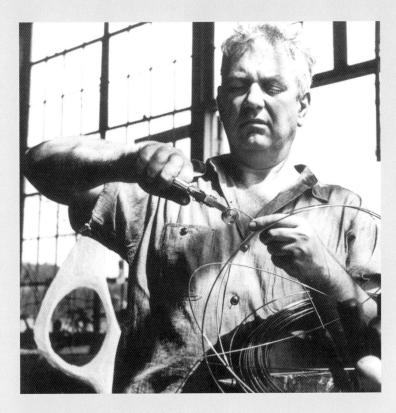

"My fan mail is enormous. Everyone is under six."

—ALEXANDER CALDER
The New York Times, August 6, 1976

ALEXANDER CALDER WAS BORN ON JULY 22, 1898, in Lawnton, Pennsylvania. Both of his parents were artists. His first workshop was in the basement of his family's home in Pasadena, California, where they had moved in 1906. There, the precocious eight-year-old made jewelry from copper and beads for his sister's dolls. At eleven, he constructed a dog and duck from sheet brass for his parent's Christmas gifts.

As a young man he moved to New York City to study engineering, but soon gravitated toward art and illustration, creating his first wire sculptures and sketching animals in the Bronx and Central Park zoos. In 1925, he traveled to Sarasota, Florida, to visit the winter home of the Ringling Brothers and Barnum and Bailey Circus. Thus began his lifelong delight in circus performers and animals, images he would later recreate in a myriad of forms and materials. Characters he fashioned from wire, wood, fabric, rubber, and leather would become participants in his Cirque Calder.

In June of 1929, aboard a ship returning to New York from France, Calder met Louisa James, whom he married in Concord, Massachusetts, six months later.

At the time, Calder was performing his Cirque Calder and his sculptures were being shown in both New York and Paris galleries.

Using cranks and small motors, Calder began concentrating on objects in motion. His friend, the artist Marcel Duchamp, suggested he call them "mobiles," a pun in French that refers to both motion and motive. Later, the artist Jean Arp offered the name "stabiles," for Calder's non-motorized constructions. Both of these terms became associated with Calder's work.

In 1934, the Calders moved into a studio in Roxbury, Connecticut and their first daughter, Sandra, was born the following year. Their second daughter, Mary, was born four years later. The first major retrospective of Calder's work opened in Springfield, Massachusetts in 1938. Five years later at another retrospective at the Museum of Modern Art in New York City Calder gave Cirque Calder performances in the penthouse.

He continued to work and exhibit his art throughout his life. In addition to his mobiles, stabiles, sculptures, and paintings, he illustrated a number of books and, in 1950, was cited as one of the ten best children's book illustrators in the past 50 years by *The New York Times Book Review*. He and Louisa divided their time between homes in Connecticut and Sache, France. He was honored with many awards for both his art and, with Louisa, his participation in the peace movement.

Alexander Calder died on November 11, 1976, at the age of 78, in New York City. Today, his work is on display throughout the world and he remains one of our most original and beloved artists.

Published in 2001 by Welcome Books,
An imprint of Welcome Enterprises, Inc.
588 Broadway, Suite 303
New York, New York 10012
(212) 343-9430; Fax: (212) 343-9434
email: info@wepub.com

Edited by Linda Sunshine
Designed by Gregory Wakabayashi

Distributed to the trade in the U.S. and Canada by
Andrews McMeel Distribution Services
Order Department and Customer Service:
(800) 826-4216
Orders Only Fax: (800) 437-8683

Library of Congress Control Number:
2001 132591

Printed in Singapore by Tien Wah Press
1 3 5 7 9 10 8 6 4 2

ILLUSTRATION CREDITS:

Cover and pages 16–17: *Untitled*, 1947, gouache and ink on paper, $22\,5/8$" x 33". Art Resource, NY. Private collection.

Page 1: *Somersaulters*, 1931, ink, $22\,3/4$" x $30\,3/4$". Mr. and Mrs. Alvin S. Lane, Riverdale, New York.

Pages 2–3: *Myxomatose*, 1953, sheet metal, rod, wire, and paint, 101" x 161". Art Resource, NY. Private Collection.

Pages 4–5: *Santos*, 1956, oil on plywood, $33\,7/8$" x $45\,1/2$". Art Resource, NY. Private Collection.

Pages 6–7: *Untitled*, 1942, sheet metal, wire, and paint, 62" x 66" x 56". Art Resource, NY. Private Collection.

Pages 8–9: *Pinwheel and Flow*, 1958, oil on plywood, $30\,1/8$" x $40\,1/8$". Art Resource, NY. Private Collection.

Page 10: *Flying Saucers*, 1969, gouache, 46" x 32". Jean and Sandra Davidson, Saché, France.

Pages 12–13: *Yellow Equestrienne*, 1975, gouache, 23" x $30\,5/8$". Mr. and Mrs. A.R. Landsman, New York.

Page 15: *Alexander Calder–Self-Portrait*, 1925, oil on canvas, 20" x 16". Smithsonian American Art Museum, Washington, DC / Art Resource, NY.

Page 18: *Goldfish Bowl*, 1929, wire, 16" x 15" x 6". Art Resource, NY. Private Collection.

Page 19: *The Brass Family*, 1929, wire, 64" h. Whitney Museum of American Art, New York; gift of artist.

Pages 20–21: *Untitled*, 1949, gouache and ink on paper, $11\,3/8$" x $15\,5/8$". Art Resource, NY. Private Collection.

Page 23: *Untitled*, 1943, gouache and ink on paper, $21\,3/4$" x $29\,3/4$". Art Resource, NY. Private Collection.

Page 24: *Untitled*, ca. 1928, wire, 13" x 9" x 13". Art Resource, NY. Private Collection.

Pages 26–27: *Movement in Space*, 1932, gouache and ink on paper, $22\,3/4$" x $30\,3/4$". National Gallery of Art, Washington; gift of Mr. and Mrs. Klaus G. Perls.

Pages 28–29: *The Flying Trapeze*, 1925, oil on canvas, 36" x 42". Art Resource, NY. Private Collection.

Page 30: Bobby McFerrin. Photograph by Ann Marsden, Original Artists, NY.

Page 31: Alexander Calder in his Roxbury studio, 1944. Photograph by Herbert Matter, Art Resource, NY.